Property of

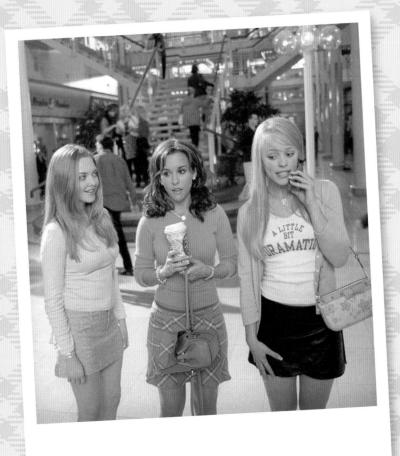

INSIGHTS

an imprint of

INSIGHT SEDITIONS

San Rafael, California www.insighteditions.com

MEANGIRLS

TM & © 2019 Paramount Pictures. All Rights Reserved.

MANUFACTURED IN CHINA 10 9 8 7 6 5 4 3 2 1